SAMMY SHARK
HAS A
BIRTHDAY WISH

Copyright © 2022 LaDonna Lombardi and Michael Lombardi
All rights reserved
First Edition

PAGE PUBLISHING
Conneaut Lake, PA

First originally published by Page Publishing 2022

ISBN 978-1-6624-2286-7 (pbk)
ISBN 978-1-6624-2287-4 (digital)

Printed in the United States of America

Sammy Shark and Friends
Book 1

SAMMY SHARK HAS A BIRTHDAY WISH

LaDonna Lombardi
and
Michael Lombardi

(son at age ten years old)

Based on illustrations by LaDonna Lombardi

Sammy Shark is a sad little shark. There is only one thing that will cheer Sammy Shark. He wants to play baseball on his birthday.

But there is a problem. Sammy Shark has fins, and a baseball glove won't fit a fin.

One day, while swimming the seven seas, Sammy Shark met the new mollusk on the block. His name was Oscar Octopus. Oscar Octopus could see his new friend was very sad.

When Sammy Shark told Oscar Octopus his birthday wish, Oscar Octopus understood why Sammy Shark was so sad.

If a baseball glove could just fit a fin, thought Oscar Octopus.

The day before Sammy Shark's birthday was a very busy day for Oscar Octopus. He was making a special present for his new friend.

Sammy Shark is very excited. Today is his birthday, and all his friends are coming to his party.

At the party, everyone is having fun. After the birthday cake, it is time to open the presents.

As Sammy Shark opened presents, he thanked each friend for the gift they had brought for him.

Only one present was left to open. This was the present that Oscar Octopus had brought for Sammy Shark.

Oscar Octopus hoped his new friend would like the gift he had made.

As Sammy Shark pulled the bright red ribbon, the top of the box came off. Floating up, **up**, **up** out of the box was a baseball glove.

Sammy Shark shouted with glee. This was not just any baseball glove. This baseball glove was made to fit a fin.

Oscar Octopus had not told Sammy Shark, but he was the greatest leather maker in the seven seas. He could make anything made of leather.

Sammy Shark and his friends spent the rest of the day playing baseball.

Sammy Shark thought this was his best birthday ever!

About the Author

LaDonna Lombardi and her husband, Mike of over forty years live in a seaside community in New York City. Their time is split between the beach and the Pocono Mountains of Pennsylvania. LaDonna is an avid Magna fisherman and enjoys the trinkets she has found over the years. As a mother of two adults and nana to six grandchildren who keep them busy, LaDonna and Mike enjoy their family time.

Michael is the son of LaDonna and Mike. Michael was ten years old when they wrote *Sammy Shark and Friends* as a school project. *Sammy Shark and Friends,* after twenty-five years, is still an inspiration to Michael and his sister, Laura who now read the books to their own children.